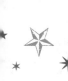

BIRTHDAYS & DA...

BIRTHDAYS		
Date	Who	Event
July 31	Harry Potter™	
September 19	Hermione Granger™	
March 1	Ron Weasley™	

YEARLY CALENDAR

JANUARY	FEBRUARY
MAY	**JUNE**
SEPTEMBER	**OCTOBER**

MARCH

APRIL

JULY

AUGUST

NOVEMBER

DECEMBER

WEEK OF

PRIORITIES / GOALS

MONDAY

TUESDAY

WEDNESDAY

THURSDAY

FRIDAY

SATURDAY

SUNDAY

WEEK OF

PRIORITIES / GOALS

MONDAY

TUESDAY

WEDNESDAY

THURSDAY

FRIDAY

SATURDAY

SUNDAY

WEEK OF

PRIORITIES / GOALS

MONDAY

TUESDAY

WEDNESDAY

THURSDAY

FRIDAY

SATURDAY

SUNDAY

WEEK OF

PRIORITIES / GOALS

MONDAY

TUESDAY

WEDNESDAY

THURSDAY

FRIDAY

SATURDAY

SUNDAY

WEEK OF

PRIORITIES / GOALS

MONDAY

TUESDAY

WEDNESDAY

THURSDAY

FRIDAY

SATURDAY

SUNDAY

WEEK OF

......................

PRIORITIES / GOALS

MONDAY

TUESDAY

WEDNESDAY

THURSDAY

FRIDAY

SATURDAY

SUNDAY

WEEK OF

PRIORITIES / GOALS

MONDAY

TUESDAY

WEDNESDAY

THURSDAY

FRIDAY

SATURDAY

SUNDAY

WEEK OF

PRIORITIES / GOALS

MONDAY

TUESDAY

WEDNESDAY

THURSDAY

FRIDAY

SATURDAY

SUNDAY

WEEK OF

PRIORITIES / GOALS

MONDAY

TUESDAY

WEDNESDAY

THURSDAY

FRIDAY

SATURDAY

SUNDAY

WEEK OF

PRIORITIES / GOALS

MONDAY

TUESDAY

WEDNESDAY

THURSDAY

FRIDAY

SATURDAY

SUNDAY

WEEK OF

........................

PRIORITIES / GOALS

MONDAY

TUESDAY

WEDNESDAY

THURSDAY

FRIDAY

SATURDAY

SUNDAY

WEEK OF

PRIORITIES / GOALS

MONDAY

TUESDAY

WEDNESDAY

THURSDAY

FRIDAY

SATURDAY

SUNDAY

WEEK OF

PRIORITIES / GOALS

MONDAY

TUESDAY

WEDNESDAY

THURSDAY

FRIDAY

SATURDAY

SUNDAY

WEEK OF

PRIORITIES / GOALS

MONDAY

TUESDAY

WEDNESDAY

THURSDAY

FRIDAY

SATURDAY

SUNDAY

WEEK OF

PRIORITIES / GOALS

MONDAY

TUESDAY

WEDNESDAY

THURSDAY

FRIDAY

SATURDAY

SUNDAY

WEEK OF

PRIORITIES / GOALS

MONDAY

TUESDAY

WEDNESDAY

THURSDAY

FRIDAY

SATURDAY

SUNDAY

WEEK OF

PRIORITIES / GOALS

MONDAY

TUESDAY

WEDNESDAY

THURSDAY

FRIDAY

SATURDAY

SUNDAY

WEEK OF

PRIORITIES / GOALS

MONDAY

TUESDAY

WEDNESDAY

THURSDAY

FRIDAY

SATURDAY

SUNDAY

WEEK OF

PRIORITIES / GOALS

MONDAY

TUESDAY

WEDNESDAY

THURSDAY

FRIDAY

SATURDAY

SUNDAY

WEEK OF

PRIORITIES / GOALS

MONDAY

TUESDAY

WEDNESDAY

THURSDAY

FRIDAY

SATURDAY

SUNDAY

WEEK OF

PRIORITIES / GOALS

MONDAY

TUESDAY

WEDNESDAY

THURSDAY

FRIDAY

SATURDAY

SUNDAY

WEEK OF

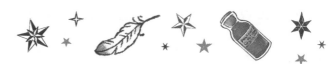

......................................

PRIORITIES / GOALS

MONDAY

TUESDAY

WEDNESDAY

THURSDAY

FRIDAY

SATURDAY

SUNDAY

WEEK OF

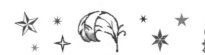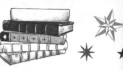

PRIORITIES / GOALS

MONDAY

TUESDAY

WEDNESDAY

THURSDAY

FRIDAY

SATURDAY

SUNDAY

WEEK OF

PRIORITIES / GOALS

MONDAY

TUESDAY

WEDNESDAY

THURSDAY

FRIDAY

SATURDAY

SUNDAY

WEEK OF

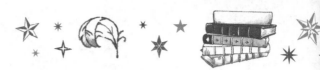

PRIORITIES / GOALS

MONDAY

TUESDAY

WEDNESDAY

THURSDAY

FRIDAY

SATURDAY

SUNDAY

WEEK OF

PRIORITIES / GOALS

MONDAY

TUESDAY

WEDNESDAY

THURSDAY

FRIDAY

SATURDAY

SUNDAY

WEEK OF

PRIORITIES / GOALS

MONDAY

TUESDAY

WEDNESDAY

THURSDAY

FRIDAY

SATURDAY

SUNDAY

WEEK OF

PRIORITIES / GOALS

MONDAY

TUESDAY

WEDNESDAY

THURSDAY

FRIDAY

SATURDAY

SUNDAY

WEEK OF

PRIORITIES / GOALS

MONDAY

TUESDAY

WEDNESDAY

THURSDAY

FRIDAY

SATURDAY

SUNDAY

WEEK OF

..........................

PRIORITIES / GOALS

MONDAY

TUESDAY

WEDNESDAY

THURSDAY

FRIDAY

SATURDAY

SUNDAY

WEEK OF

PRIORITIES / GOALS

MONDAY

TUESDAY

WEDNESDAY

THURSDAY

FRIDAY

SATURDAY

SUNDAY

WEEK OF

PRIORITIES / GOALS

MONDAY

TUESDAY

WEDNESDAY

THURSDAY

FRIDAY

SATURDAY

SUNDAY

WEEK OF

PRIORITIES / GOALS

MONDAY

TUESDAY

WEDNESDAY

THURSDAY

FRIDAY

SATURDAY

SUNDAY

WEEK OF

PRIORITIES / GOALS

MONDAY

TUESDAY

WEDNESDAY

THURSDAY

FRIDAY

SATURDAY

SUNDAY

WEEK OF

PRIORITIES / GOALS

MONDAY

TUESDAY

WEDNESDAY

THURSDAY

FRIDAY

SATURDAY

SUNDAY

WEEK OF

PRIORITIES / GOALS

MONDAY

TUESDAY

WEDNESDAY

THURSDAY

FRIDAY

SATURDAY

SUNDAY

WEEK OF

PRIORITIES / GOALS

MONDAY

TUESDAY

WEDNESDAY

THURSDAY

FRIDAY

SATURDAY

SUNDAY

WEEK OF

PRIORITIES / GOALS

MONDAY

TUESDAY

WEDNESDAY

THURSDAY

FRIDAY

SATURDAY

SUNDAY

WEEK OF

........................

PRIORITIES / GOALS

MONDAY

TUESDAY

WEDNESDAY

THURSDAY

FRIDAY

SATURDAY

SUNDAY

WEEK OF

PRIORITIES / GOALS

MONDAY

TUESDAY

WEDNESDAY

THURSDAY

FRIDAY

SATURDAY

SUNDAY

WEEK OF

PRIORITIES / GOALS

MONDAY

TUESDAY

WEDNESDAY

THURSDAY

FRIDAY

SATURDAY

SUNDAY

WEEK OF

PRIORITIES / GOALS

MONDAY

TUESDAY

WEDNESDAY

THURSDAY

FRIDAY

SATURDAY

SUNDAY

WEEK OF

PRIORITIES / GOALS

MONDAY

TUESDAY

WEDNESDAY

THURSDAY

FRIDAY

SATURDAY

SUNDAY

WEEK OF

PRIORITIES / GOALS

MONDAY

TUESDAY

WEDNESDAY

THURSDAY

FRIDAY

SATURDAY

SUNDAY

WEEK OF

PRIORITIES / GOALS

MONDAY

TUESDAY

WEDNESDAY

THURSDAY

FRIDAY

| SATURDAY | SUNDAY |

WEEK OF

PRIORITIES / GOALS

MONDAY

TUESDAY

WEDNESDAY

THURSDAY

FRIDAY

SATURDAY

SUNDAY

WEEK OF

PRIORITIES / GOALS

MONDAY

TUESDAY

WEDNESDAY

THURSDAY

FRIDAY

SATURDAY

SUNDAY

WEEK OF

PRIORITIES / GOALS

MONDAY

TUESDAY

WEDNESDAY

THURSDAY

FRIDAY

SATURDAY

SUNDAY

PRIORITIES / GOALS

MONDAY

TUESDAY

WEDNESDAY

THURSDAY

FRIDAY

SATURDAY

SUNDAY

WEEK OF

PRIORITIES / GOALS

MONDAY

TUESDAY

WEDNESDAY

THURSDAY

FRIDAY

SATURDAY

SUNDAY

WEEK OF

PRIORITIES / GOALS

MONDAY

TUESDAY

WEDNESDAY

THURSDAY

FRIDAY

SATURDAY

SUNDAY

WEEK OF

PRIORITIES / GOALS

MONDAY

TUESDAY

WEDNESDAY

THURSDAY

FRIDAY

SATURDAY

SUNDAY

ADDRESS

NAME: _____

ADDRESS: _____

PHONE: _____

EMAIL: _____

WEB ADDRESS: _____

NAME: _____

ADDRESS: _____

PHONE: _____

EMAIL: _____

WEB ADDRESS: _____

NAME: _____

ADDRESS: _____

PHONE: _____

EMAIL: _____

WEB ADDRESS: _____

ADDRESS

NAME: _____

ADDRESS: _____

PHONE: _____

EMAIL: _____

WEB ADDRESS: _____

NAME: _____

ADDRESS: _____

PHONE: _____

EMAIL: _____

WEB ADDRESS: _____

NAME: _____

ADDRESS: _____

PHONE: _____

EMAIL: _____

WEB ADDRESS: _____

ADDRESS

NAME: _____

ADDRESS: _____

PHONE: _____

EMAIL: _____

WEB ADDRESS: _____

NAME: _____

ADDRESS: _____

PHONE: _____

EMAIL: _____

WEB ADDRESS: _____

NAME: _____

ADDRESS: _____

PHONE: _____

EMAIL: _____

WEB ADDRESS: _____

ADDRESS

NAME: _____

ADDRESS: _____

PHONE: _____

EMAIL: _____

WEB ADDRESS: _____

NAME: _____

ADDRESS: _____

PHONE: _____

EMAIL: _____

WEB ADDRESS: _____

NAME: _____

ADDRESS: _____

PHONE: _____

EMAIL: _____

WEB ADDRESS: _____

NOTES

NOTES

NOTES

NOTES

Harry Potter™

INSIGHTS

www.insighteditions.com

MANUFACTURED IN CHINA

10 9 8 7 6 5 4 3 2 1